VINCENT VAN GOGH

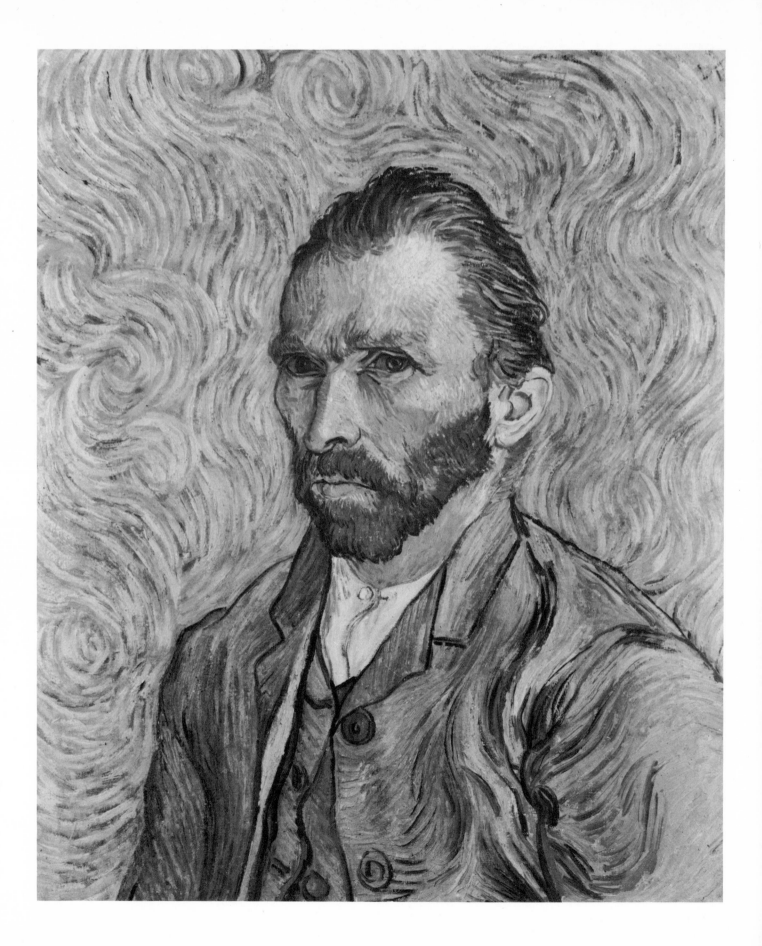

VAN GOGH

Grose Evans

The National Gallery of Art
Washington, D.C.

McGRAW-HILL BOOK COMPANY · NEW YORK · LONDON · TORONTO · SYDNEY

19763

Cover picture, *Dr. Gachet* (May, 1890), etching, The National Gallery of Art, Washington, D.C., Rosenwald Collection. Photograph for Frontispiece, courtesy Giraudon.

No OTHER ARTIST of his time accomplished so much in so short a career as Vincent van Gogh; ten years comprised his entire artistic activity. Through astonishing originality, which molded traditions to his own expressive purposes, Van Gogh created an art that had a powerful impact upon his successors. His work profoundly shaped the Fauve movement early in this century, and was a point of departure for abstract expressionism in our own age.

The development of Van Gogh's art can be understood most easily when it is divided into three phases. The first period of about five and a half years, from August, 1880 to February, 1886, includes his studies in Holland and Belgium—the drawings of peasants and landscapes and the oil paintings done with a traditional palette of earth colors. This phase is followed by his still-formative two years in Paris, February, 1886 to February, 1888, during which time he experimented with the bright colors of Impressionism and Neo-Impressionism, and also discovered Japanese prints, which influenced his style profoundly. Then, in a period of only slightly over two years, from February, 1888 until his death in July, 1890, he achieved at Arles, Saint-Rémy, and Auvers, the highly expressive, individual manner of painting which has made him so justly famous.

Vincent Willem van Gogh was born March 30, 1853, in Groot-Zundert, North Brabant, Netherlands. He was the eldest son of a Protestant clergyman whose conventional moral, ethical, and social ideas were at variance with the free-thinking standards Vincent evolved from much reading, particularly from the Bible, the histories by Michelet and Renan, and the novels of Charles Dickens. Van Gogh lived less "by the book" than by his own feelings for social justice and his sympathy with underprivileged people. In his maturity he developed a headstrong, argumentative manner, bordering upon eccentricity, which prevented intimate relationships with his family and even most of his acquaintances. Only his brother Theo, four years younger, whose saintly patience was often tried, remained devoted to him, and supported him financially throughout his brief, turbulent life. Due to the voluminous correspondence

Frontispiece.
[Facing title page]
Self-Portrait
(May, 1890)
oil, 25½″ x 21¼″
Louvre, Paris

[Facing this page]
Detail of Frontispiece

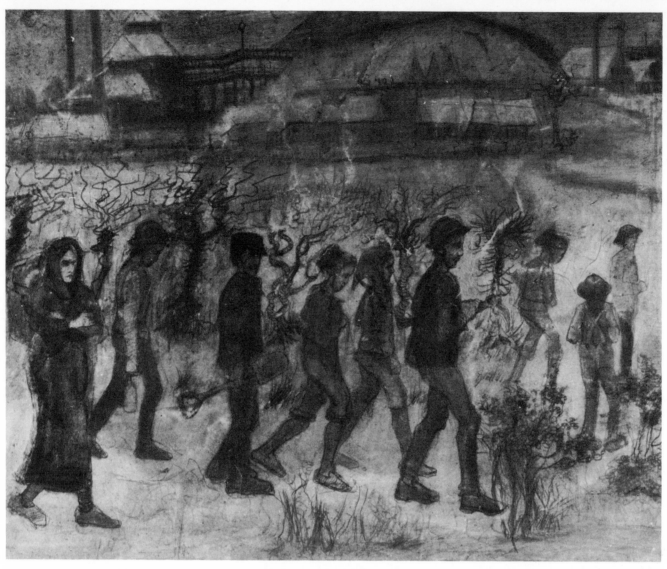

Figure 1.
Miners
(August, 1880)
pencil touched with color
17⅜″ x 22″
Rijksmuseum Kröller-Müller
Otterlo

between these brothers, as well to the letters Van Gogh wrote to a few other friends and occasionally to his family, a far more intimate knowledge of his struggles and his character exists than in the case of any other artist. His developing personality and art have proved irresistible to novelists and psychologists, as well as to students of art, so that while many books have been written about him, only a few authors have studied his paintings perceptively.

In 1869, at sixteen, Van Gogh began to work for Goupil and Company, art dealers in The Hague, where his uncle Vincent was a partner. A few years later, with good expectations, he was transferred to the London branch, but while there he suffered the shock of his first rejection in love; his landlady's daughter refused his offer of marriage. The ensuing despondency hampered his efficiency, and his firm transferred him to Paris in the hope he would forget his troubles. But almost every encounter with women was shattering to Van Gogh's personality, and in the next year, 1876, he was dismissed by Goupil's.

Briefly he turned to teaching school in England, but, having an intense admiration for his father's calling, he preoccupied himself with religion and began study for

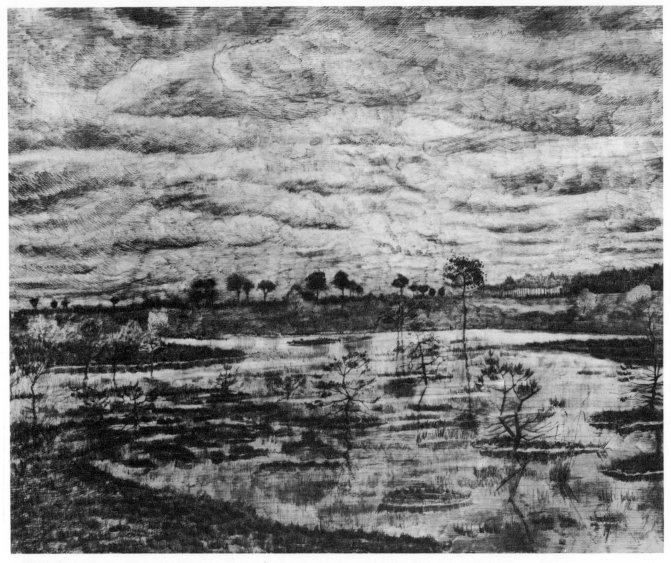

entrance to a theological seminary. When he failed to qualify, he volunteered for service among the coal miners of the Borinage in southern Belgium. Here he projected himself completely into their lives, even to sharing his meager funds with them, descending the most dangerous shafts, and rubbing coal dust into his face and hands so that he could be like them. Such behavior baffled the miners as well as his superiors and again he was dismissed. Still, at his own expense, he continued working briefly at Cuesmes, where he made some of his earliest drawings.

A timid work of this time, 1880, (Figure 1), shows miners trudging to work against a "hedge of thorns." Evidently at this point he was motivated more by pity than by talent. He acknowledged to Theo his need to still study figure drawing from Millet, Breton, and others. Actually, the figures in this drawing are individually well conceived, but they lack firm draftsmanship, and their compositional unity is inadequate since they give the feeling of accidental arrangement. However, only one year later, when living again with his parents, now at Etten, he drew with pencil and pen the striking *Marsh Landscape* (Figure 2), which reveals to a remarkable degree his ability to see broadly and to unify his vision in terms of the surface he was working upon. While

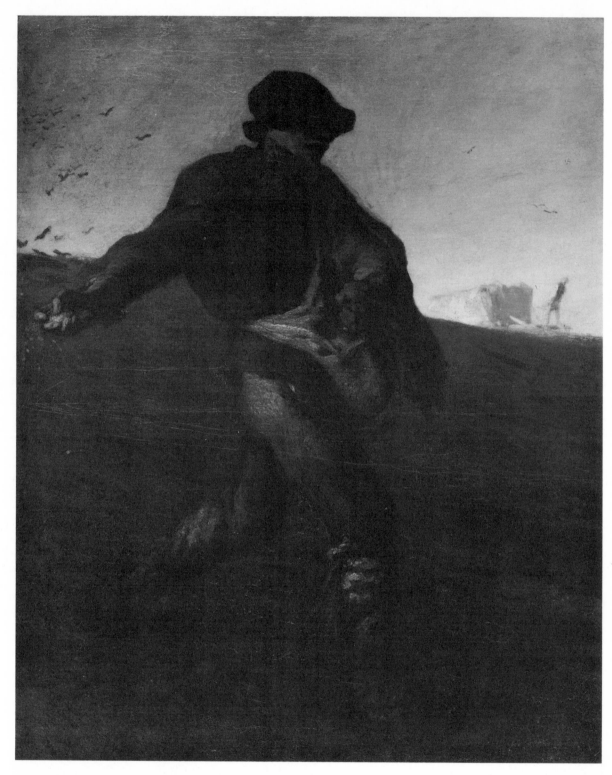

Figure 3.
Jean François Millet (1814–1875)
The Sower (c. 1850)
oil, 39¾″ x 32½″
Courtesy Boston Museum of Fine Arts, Shaw Collection

its subject is one that would appeal readily to a beginner because of its picturesque contrasts of light and dark, Van Gogh does not neglect the subtle middle tones in the clouds and grasses, and further, he sensitively captures an appealing mood of melancholy.

Around this time Van Gogh suffered his second severe rejection in love, now from his widowed cousin Kornelia who was visiting his parents in Etten. Unable to believe that she did not reciprocate his feelings, he followed "K" to her home in Amsterdam. There her parents refused to let him speak with her, but he pleaded with them to be able to see her for only as long as he could hold his hand in the flame of a lamp. When he actually thrust his hand into the flame, her horrified parents turned him out of the house.

In this same year, 1881, he began his series of peasant studies, based on his strong enthusiasm for Jean François Millet's work and on his own deep sympathy with peasant life (Figure 3). Millet was one of his few salutary early influences for he also admired a great deal of hack work by now-forgotten magazine illustrators, whose technical virtuosity was matched only by the conventionality of their sentimental feelings. Avidly he collected their works; Herkomer, Hol, Walker, even the American Caton Woodville were among his favorites. This fact pathetically reveals how out of touch with current cultural trends Van Gogh remained until his trip to Paris. Only Millet, together with Daumier and Monticelli, whose works he liked, revealed to him an admirable breadth of design.

His own drawing of *The Sower* (Figure 4) recalls Millet's famous composition, but instead of copying the heroic sentiment of that picture, Van Gogh has painstakingly reworked his figure from a humble, actual model. Studying from models, having the subject before him, became an obsessive necessity. Although he was often nearly starving during the next four years, he continued to pay models out of the small sums his brother sent him. While occasionally he tried to compose from memory or imagination, for him the results became "abstractions," lacking physical and emotional reality. One can sense the importance of actuality in his version of *The Sower,* in the honestly drawn face and hands, even in the folds of the costume and the precise placement of the wrinkled boots; all have been accounted for meticulously and are evidence of his deep sincerity.

In landscapes, such as *The Roots* (Figure 5), the same searching for truthful expression is apparent. Worked with crayon and touched with white, it does not stop at giving a picturesque silhouette of irregular dark branches against a misty sky, but it explores the spatial relationships between each root and each branch until they seem alive despite the air of contorted death in the trees themselves.

The Roots was drawn in The Hague, where Van Gogh went in December, 1881. There he studied briefly with the successful painter, Anton Mauve, who had married Van Gogh's cousin. While in The Hague, he lived in severe poverty for over two years;

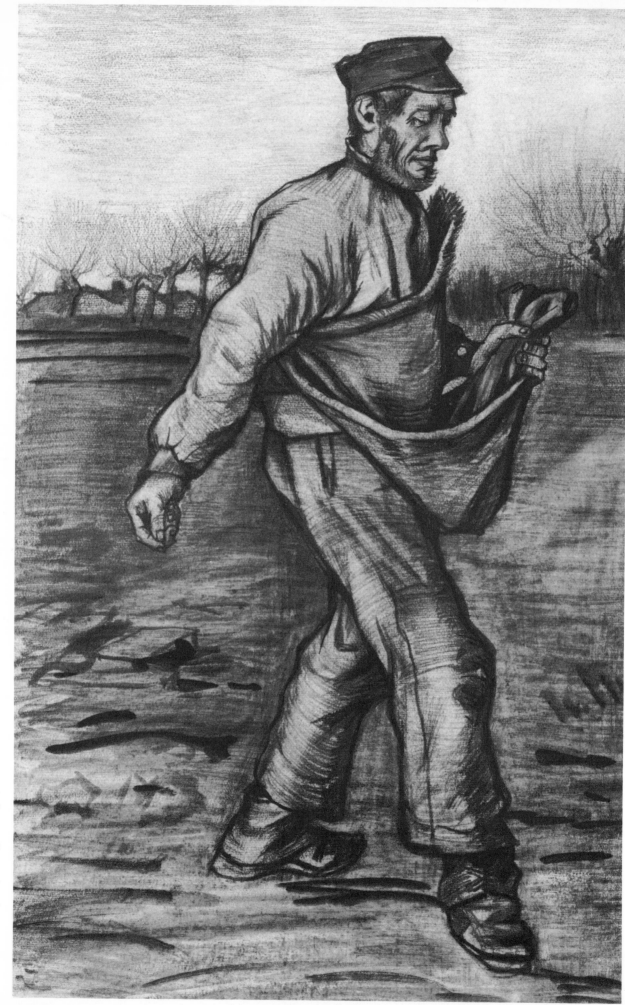

Figure 4.
The Sower
(September, 1881)
pen and brush
35½″ x 24″
Collection P. de Boer
Amsterdam

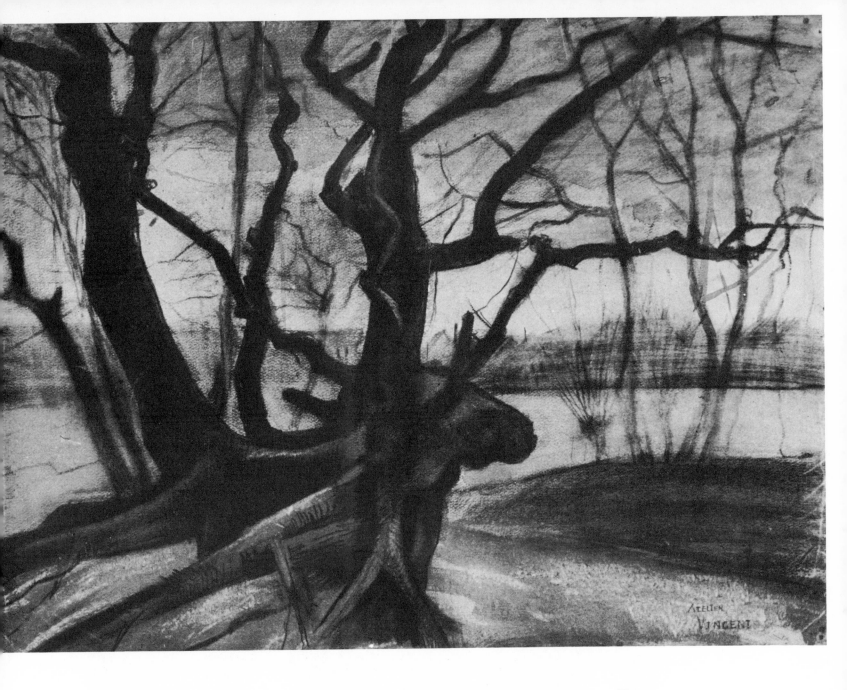

nevertheless, desperate for affection, he shared his lodging with a prostitute, Christine (and her two children), in the hope of reforming her. The experience gave him an illusion of having a family, but the woman could offer no intellectual companionship and her presence drove his friends from his house. Quite possibly the drawing *Woman Mourning* (Figure 6) represents Christine, since the face is similar to identified pictures of her. Drawn in black lead and ink, it exhibits a far richer range of tone than the earlier study of *The Sower,* and the careful delineation of the forms is well sustained even in the intricate flounces of the skirt and the exacting foreshortenings of the chair.

Van Gogh's early works should be evaluated against the art he knew while he was still in Holland. He admired the Dutch old masters, especially Hals and Rembrandt,

Figure 5.
The Roots
(April, 1882)
crayon heightened with white
19¼″ x 26¾″
Rijksmuseum Kröller-Müller
Otterlo

Figure 6.
Woman Mourning
(April, 1882)
black lead and ink
19¾″ x 17″
Rijksmuseum Kröller-Müller
Otterlo

but otherwise his taste was formed by mid-century realists. Among the most respected of these was Joseph Israëls, whose *Interior of a Cottage* is shown here (Figure 7). Its sentimental realism had spent itself during the two decades before Van Gogh started his career, yet it represents the trend he felt he must compete with while in Holland. In comparison with Israëls' work his own style seemed extremely crude, but its telling force is evident in such a powerful example as *At Eternity's Gate* (Figure 8). This single monumental figure, copied as a lithograph from one of his own drawings, is an archetypal symbol of the despair of old age—entirely unforgettable. It was originally drawn in 1882, but it so haunted Van Gogh that he painted a canvas after it in 1890, the year of his own death.

After a trip to Drenthe in northeast Holland, where he responded to the flat, melancholy scenery, in 1884 Van Gogh rejoined his parents, who had moved to a new parish in Nuenen. He remained here for about two years, often embarrassing his parents by his odd behavior. But when his mother broke her leg and he nursed her with all the fervor he had shown the Borinage miners, relations were eased in the family. Unfortunately, a neighbor's daughter fell in love with him and their projected marriage met with such resistance from the girl's family that she attempted suicide; scandal ensued and the vicarage was avoided by the villagers.

Van Gogh rented a studio nearby, where he concentrated upon studies of peasants weaving and digging potatoes. Previously he had tried to combine some of his figure studies into large compositions, but they lacked unified action and not until 1885 could he produce a successful figure composition, *The Potato-Eaters* (Slide 2). This work had been preceded by a great many studies, some of them drawn with the forcefulness of caricatures to emphasize the very qualities that set peasants apart from the wealthier classes (Figure 9). Others were painted with brutal contrasts of light and shadow to stress the rugged changes of plane in their gaunt faces (Figure 10).

These sketches embody Van Gogh's first strikingly original style. Daumier comes to mind as a prototype, yet it is doubtful if Van Gogh knew Daumier's paintings at all; probably only the newspaper lithographs were familiar to him, and they would hardly have suggested this style. Rembrandt, too, might have been a source, since Van Gogh knew Rembrandt's work from public collections in The Hague and Amsterdam. However, Van Gogh's impact upon us in the Nuenen pictures is quite distinctive, for we experience less aesthetic distance than when looking at Rembrandt's studies. Van Gogh's intensity of observation produced an unprecedented close-up, entirely original in its angularity and emotional impact. As a total composition, *The Potato-Eaters* may suffer from this determined examination in which each head and hand becomes an issue in itself, but it culminates Van Gogh's first style, and its deep sincerity is typical of this early phase.

Soon after painting *The Potato-Eaters* and following the death of his father, he went for a few months to Antwerp to study in the Academy. Rubens' art attracted

Figure 7.
Joseph Israëls (1824–1911)
Interior of a Cottage
oil
44¾″ x 66¼″
The Corcoran Gallery of Art
Washington, D.C.

him in the Antwerp Museum and induced him to lighten his colors. Once more he lived without adequate food in order to buy drawing and painting materials; his condition was described by a doctor as near-prostration in February, 1886, just before he joined Theo in Paris.

For two years in Paris Van Gogh shared Theo's lodgings, and soon after his arrival, they moved into larger quarters. His sketch of the view over Paris from his new studio window (Figure 11), a vista that delighted both brothers, shows that he had joined the ranks of the Neo-Impressionists, even though he was temperamentally unsuited to continue their laborious pointillist technique. At first he had attended Cormon's academic studio to draw from models and plaster casts. There he met Toulouse-Lautrec and Émile Bernard; the latter remained a friend and correspondent throughout his life.

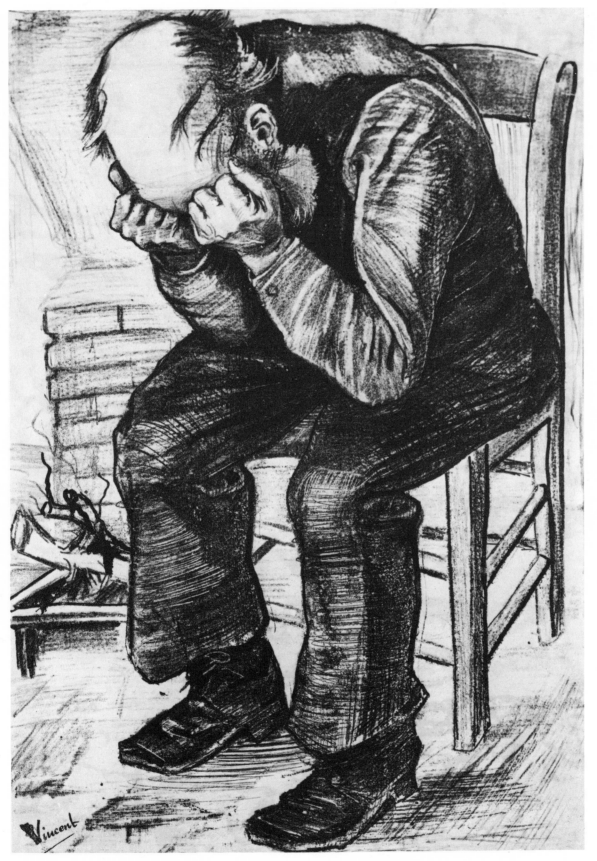

Figure 8.
At Eternity's Gate
(November, 1882)
lithograph
19⅝″ x 13¾″
Collection
Vincent van Gogh Foundation
Amsterdam

Figure 9.
Head of a Peasant Woman
(February–April, 1885)
black crayon
15¾″ x 13″
Collection
Vincent van Gogh
Foundation, Amsterdam

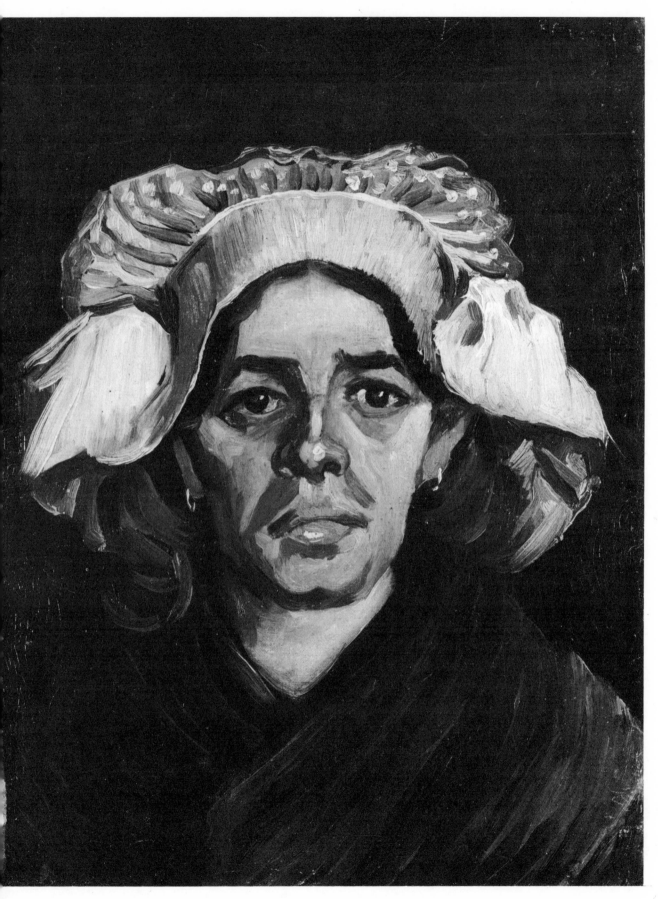

Figure 10.
Peasant Woman with Brabant Headdress
(1884–1885)
oil, 17¾″ x 14⅛″
Collection
Vincent van Gogh Foundation
Amsterdam

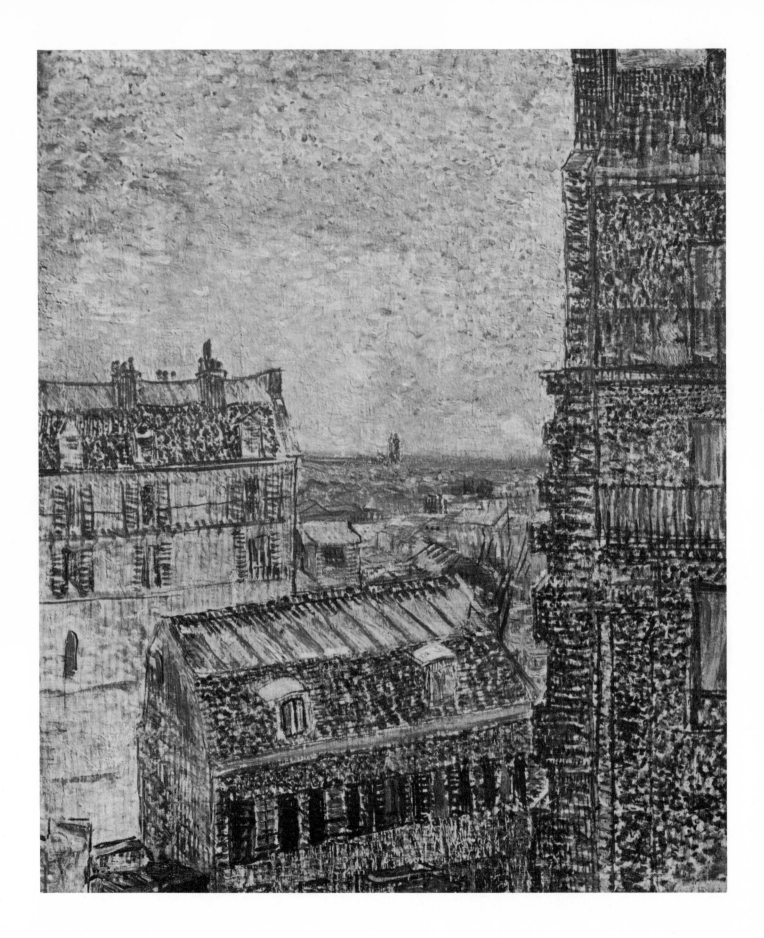

Figure 11.
*View from the Artist's
Studio at Rue Lepic*
(1887)
oil, 18¼″ x 15″
Collection
Vincent van Gogh Foundation
Amsterdam

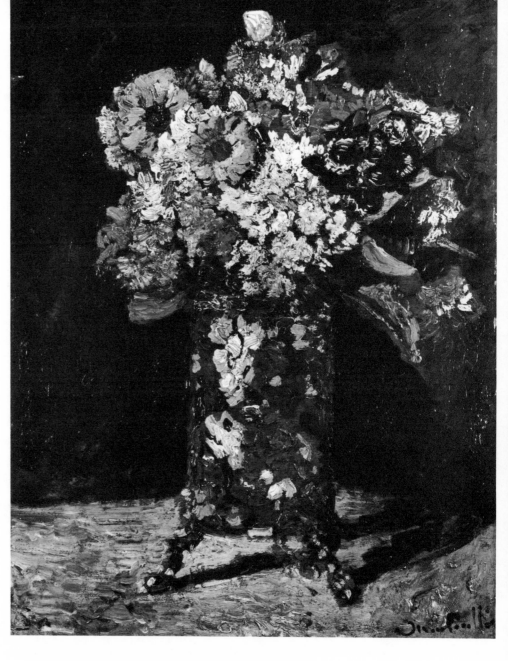

Figure 12.
Adolphe Monticelli (1824–1886)
Vase with Flowers
(1875–1880)
oil, 20″ x 15⅜″
Collection
Vincent van Gogh Foundation
Amsterdam

When he became familiar with Theo's other friends, Pissarro, Monet, Degas, Guillaumin, Seurat, Signac, and Gauguin, he gave up studio work, and often went out to the suburbs to paint (Slide 3). He evolved a new freedom in handling his colors, a lightness of touch, which no longer showed the brutally applied impasto of his early work. While Monticelli's heavy application of paint had influenced him even earlier, now he could study the *Vase of Flowers* in his brother's possession (Figure 12), and he painted many similar still lifes. But the golden browns of Monticelli and Millet soon gave way to the light, atmospheric hues of his new friends. He and Theo joined them in discussions at cafés in Montmartre, and learned to know the works of other moderns in the favorite art-supply shop of Père Tanguy (Slide 4), where, among others,

Cézanne's pictures could be seen. Van Gogh even exhibited here and in the cafés, but without success in selling his work.

It was now in Paris that Van Gogh entered the mainstream of European art, an event that made possible his own outstanding contributions. Despite his conservative earlier training, he identified himself, not with successful academic realists, but with the small group of painters, still far from winning wide recognition, who were producing really vital work. In this perceptive decision Theo probably had a hand, since the latter's best friends were among the Impressionists, Neo-Impressionists, and future Symbolists, but certainly the move was as much due to Vincent's own acute perception of what was significant in art.

To discover what influences affected Van Gogh in Paris, one should recall the artistic developments there between 1886 and 1888. In June, 1886, the last Impressionist exhibition closed. Monet, Renoir, and Sisley, prime movers in Impressionism, had refused to exhibit because Pissarro had insisted that Seurat and Signac be included. Nevertheless, while Impressionism as a movement was disintegrating, its members were still very productive and the colorful vibrancy of their brush strokes, suggesting the shimmer of sunlight, must have revolutionized Van Gogh's conception of coloring.

More immediately, however, he was affected by the advice of the Neo-Impressionist Signac, who under Seurat's influence had won over Pissarro to the pointillist technique of using tiny spots of color in a really systematic way (Figure 13). Van Gogh, always fascinated by color theories, was already familiar with Delacroix's ideas, which he had reported faithfully to Theo in an earlier letter. But Delacroix had not liberated him from using dark colors, because as Signac pointed out in his book, *From Delacroix to Neo-Impressionism,* Delacroix had combined pure prismatic hues with earth colors so that his pictures lacked real brilliance. Although Delacroix had understood that juxtaposed complementary colors—red-green, yellow-violet, blue-orange—augment each other's intensity, he had diluted their effectiveness with dark shades. In contrast, the darkest tones Signac used were the pure colors. Further, Delacroix had mixed his colors on his palette instead of relying on "optical mixture," a new and highly recommended technique behind which lay the researches of Eugène Chevreul of the Gobelin tapestry factory, as well as other scientists who had also analyzed color vision. Optical mixture depends upon the ability of the eye to merge the light rays from very small dots of color so that from a distance one color of light would appear added to another to give the effect of a new, more brilliant hue. (One can see this effect in most color reproductions; if they are examined under a powerful magnifying glass, separate dots of color appear which are not evident to the naked eye.)

Signac charged that the Impressionists had failed to achieve real brightness because they had not used touches of paint small enough to permit optical mixture, and also because, with their intuitive procedures, they had not methodically juxtaposed complementary hues to gain maximum color intensity. Curiously enough, however, the

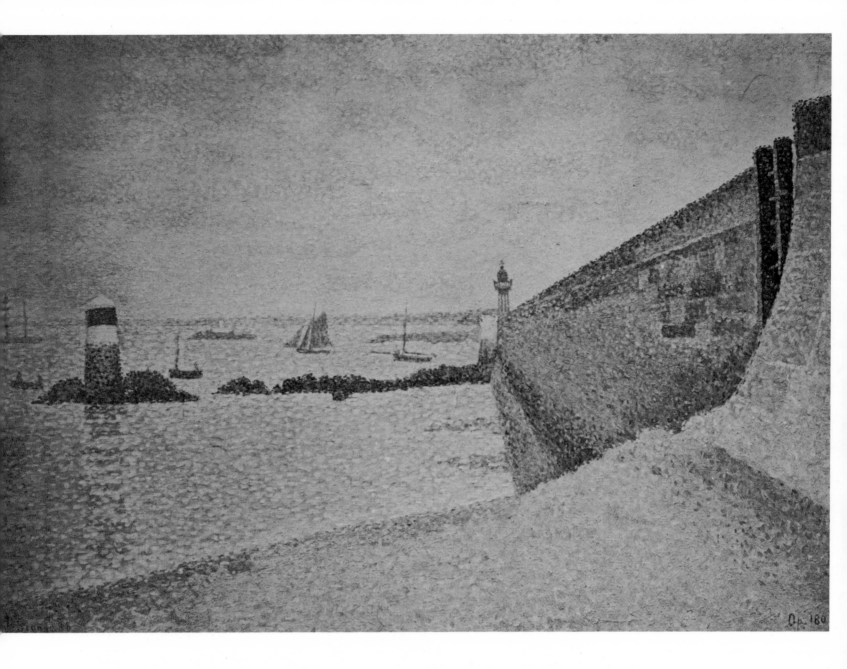

Figure 13.
Paul Signac (1863--1935)
Pier at Port-Rieux (1888)
oil, 18⅛″ x 25⅝″
Rijksmuseum Kröller-Müller
Otterlo

Impressionists' works appear brighter than Seurat's or Signac's. This may be due to several reasons: the pointillist touches of paint may be sometimes too small to register on the eye from a reasonable viewing distance, and hence are lost, while the broader touches of the Impressionists are really more effective; or again, the tiny touches of paint may actually merge their colors and merely give a dull gray effect of light. Finally, the more generous tonal contrasts in Impressionist pictures may suggest brighter effects of light than Neo-Impressionism could command.

Whatever the reasons, one can see that Van Gogh did not take pointillism seriously for very long (Slides 3 and 5). Although painting with Signac, he rarely submitted to the tedious discipline of painting in small dots; in fact, he soon lengthened his

touches of paint until they assumed a very distinctive rhythmical calligraphy, which has nothing to do with either Impressionism or Neo-Impressionism. He was really not interested in pinning down vivid sensations of light as such, so that his brushwork soon served instead to increase the feeling of life in the surfaces he painted, and to reinforce his draftsmanship.

At this same time Cézanne was also independently feeling his way beyond Impressionism toward a similar strengthening of forms, while Degas and Toulouse-Lautrec, although using impressionistic broken color, had never surrendered their draftsmanship. Even Renoir had turned from Impressionism to his "dry period," where he strove after drawing as precise as Ingres'. In short, at the moment Van Gogh arrived in Paris, new directions beyond Impressionism were being adopted. Gauguin, who was ultimately a major influence upon Van Gogh, had not yet formulated his ideas of color symbolism, but his Cézanne-like, solid still lifes and earliest landscapes from Brittany and Martinique must have impressed Van Gogh.

Unfortunately, the happy time of discovering new friends and a new, vital world of art did not last. Van Gogh's conflicting nature, sometimes fiercely dictatorial and yet often tender and sensitive, rendered Theo's life almost unendurable. Their friends deserted them, fearing Vincent's wild, interminable arguments. His health, too, had suffered from much drinking and smoking, and the bohemian life of Paris was proving overly exciting for his nerves. Determined to retire to a quiet town, he was drawn to southern France through the curious idea that it might resemble Japan. In Paris he had learned to admire Japanese prints, which had already stimulated Manet and Whistler; their simple structural outlines, arbitrary perspective, and areas of flat color became an important influence on his mature art. Also, he had read romantic novels about Japan, and hoped that the hot sun of southern France would open to him a more "Japanese" way of seeing nature.

In February, 1888, Van Gogh settled in Arles and began at once to respond emotionally and very originally to its landscape. Signac later noticed that the brighter sun here really bleached colors out of nature, but, curiously, Van Gogh did not experience this. Instead, he intensified his colors as if to interpret the blaze of sunshine through their brightness (Slides 1 and 6 through 10). He may already have been familiar with Gauguin's advice to his followers to increase the brilliance of colors in landscapes; at least, he later repeated it in a letter to Theo.

Van Gogh also adopted in his drawings what he may have felt was a Japanese style. *The Plain of La Crau* (Figure 14) was done with a pen cut from a reed; its strokes give form, spatial recession, and textural variety with hardly a hint of light and shade: the Oriental style has superseded the Western tradition of chiaroscuro. The same technique of drawing was applied even more boldly in *Street in Saintes-Maries* (Figure 15), which recalls a brief trip Van Gogh took to that seaside village near Arles. Probably Neo-Impressionism with its very small dots of paint, or even the drawings

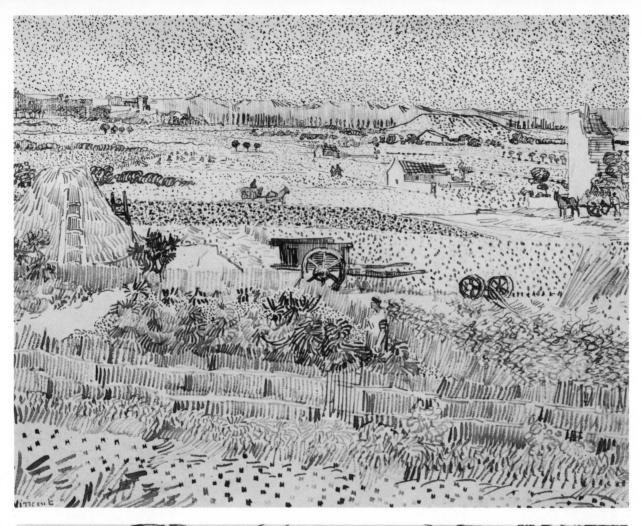

Figure 14.
The Plain of La Crau
(June, 1888)
reed pen and ink
9½″ x 12¾″
Collection of
Mr. and Mrs. Paul Mellon
Washington, D.C.

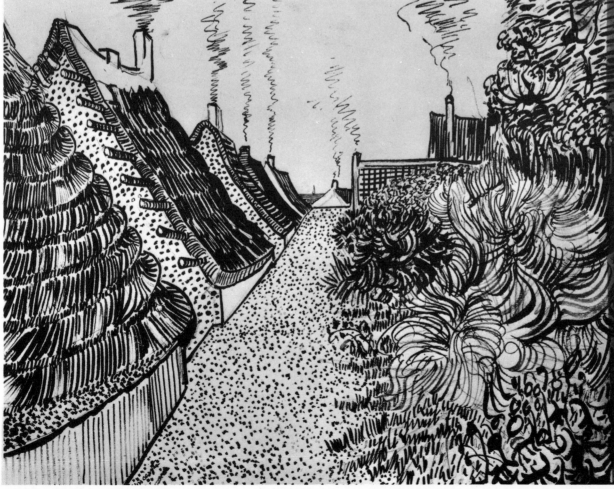

Figure 15.
Street in Saintes-Maries
(June, 1888)
brush, reed pen, and ink
9⅝″ x 12½″
The Museum of Modern Art
New York
Abby Aldrich Rockefeller Bequest

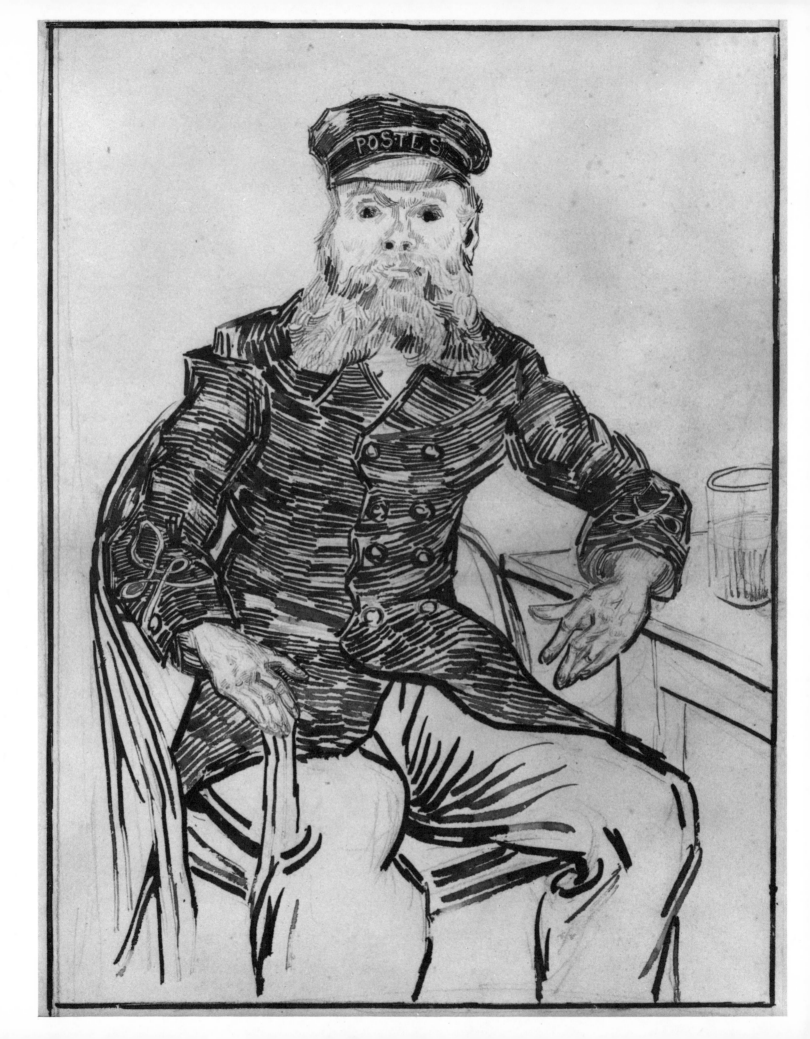

of Signac, suggested to Van Gogh that broad areas might be toned with stippling and short broken lines. However, neither the small dots nor the rhythmic successions of pen strokes give atmospheric effects of light. Instead, they establish broad, flat patterns, very Oriental in appearance.

Applied to portraiture, as in *The Postman Roulin* (Figure 16), the Oriental technique is obliged to make some concessions to Western style; shadows occur below the hat brim and the nose, but the suggestive power and direction of the pen strokes themselves really evoke a living quality in the beard, the features, and the oddly seething surface of the coat. One is aware of a new remarkable originality in Van Gogh's art. After further absorbing influences from Impressionism, Neo-Impressionism, and Japanese art, he had introduced, again, a completely distinctive style.

Van Gogh made few friends in Arles. Closest to him was Roulin, a conservative, who Van Gogh thought looked like Socrates. Evidently he was a compulsive talker, and enjoyed Van Gogh as an audience. Besides Roulin, his other chief companion was a Zouave (an Algerian in the French army), who enjoyed drawing with Van Gogh but thought he became a madman whenever he started to paint. So, it is small wonder that Van Gogh began to think of bringing into Arles some fellow artists to form "a school of the south." After many anxious months Gauguin was persuaded to join him at Theo's expense. Carefully, Van Gogh prepared and decorated his house to receive him (Slide 10).

Their association at first was stimulating, but the tensions that developed between the sophisticated Gauguin and the naive, headstrong Van Gogh led to Vincent's first mental breakdown. After menacing Gauguin with a razor in the street one evening, Van Gogh returned to his house and cut off his own left ear. Gauguin called Theo and extricated himself by returning hastily to Paris, while Van Gogh was taken to the hospital at Arles. From there, in May, 1889, he voluntarily entered an asylum near Saint-Rémy, about twelve miles from Arles. His first attack of epileptoid psychosis, a latent mental epilepsy, had terrified him and robbed him of the self-assurance necessary to live by himself. Still, he clung to the hope that if his physical needs were attended to, he might continue painting and thus regain mental stability through his work.

The asylum, still in use today, occupied a twelfth-century monastery surrounded by the wheat fields and olive orchards that Van Gogh painted (Slide 16). At first he was reassured to find his illness shared by the other inmates, but eventually he became convinced that continued residence in an insane asylum increased his seizures, which happened every two or three months. In the intervals between them, he was perfectly lucid and was allowed to paint in a room provided as a studio, or even out-of-doors. Now he discovered the beauty of cypress trees (Figure 17 and Slide 17), which are handsome, dark accents in the landscape when seen from a distance, but when closely examined are found to contain flamelike, upward-surging rhythms, to which Van Gogh probably attached the meaning of life-renewal.

Figure 16.
The Postman Roulin
(August, 1888)
ink and crayon
23¼″ x 17½″
Los Angeles County Museum of Art
The Mr. and Mrs. George
Gard de Sylva Collection

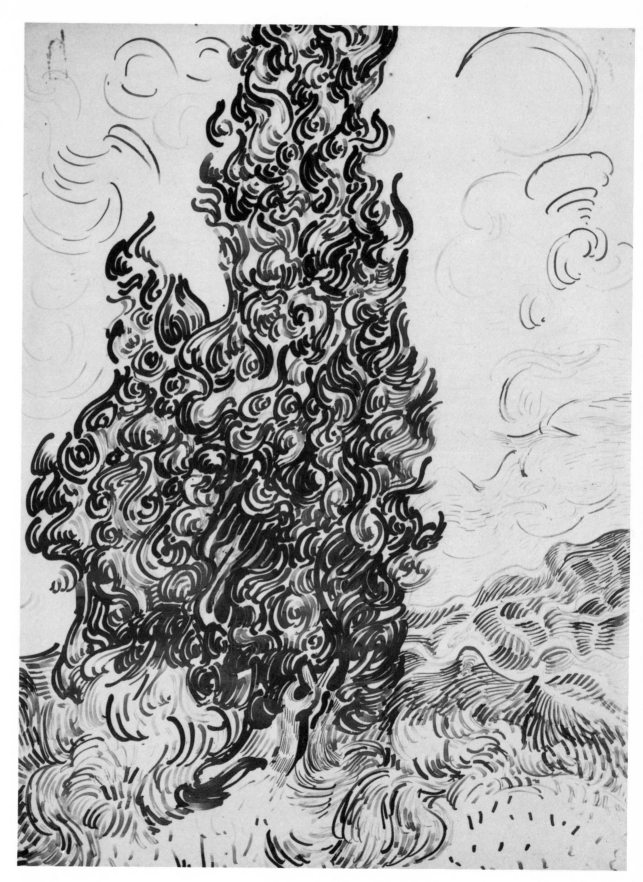

Figure 17.
Cypresses
(June, 1889)
reed pen and bistre-colored ink
32¼″ x 24¾″
Brooklyn Museum, New York

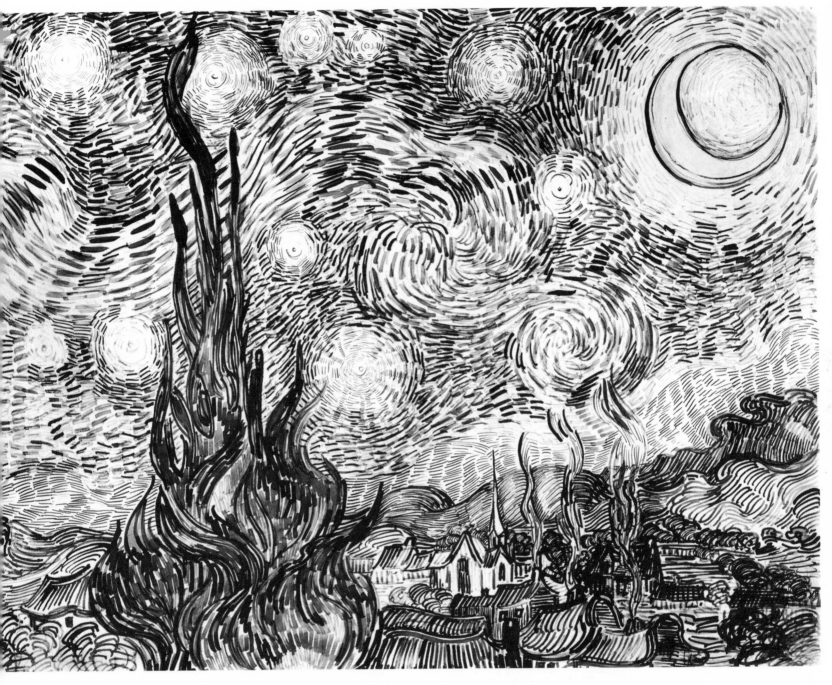

Such mystical symbolism, recurring in his art and his letters, certainly motivated his famous *Starry Night,* a preliminary drawing of which is shown in Figure 18. It climaxes previous trends in its vital draftsmanship and freedom of design, but more clearly than any other previous work it opens a new direction toward purely subjective expressionism. The explosive dynamism of the sky, with its swirling nebula, dazzling stars, and extraordinary moon, is an hallucinatory vision, revealing Van Gogh's search for the infinite, a profoundly religious quest for evidence of God in nature. He knew that

Figure 18.
Cypresses by Moonlight
(June, 1889)
pen and ink
18½″ x 24⅝″
Kunsthalle, Bremen
This work was destroyed
in World War II

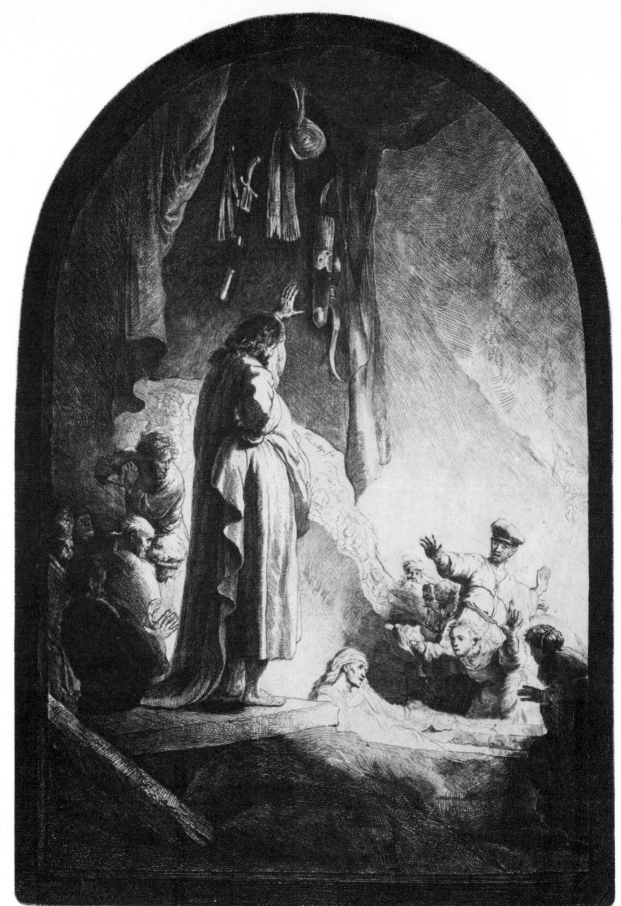

Figure 19.
Rembrandt van Rijn
(1606–1669)
The Raising of Lazarus
(the larger plate)
etching
14$\frac{7}{16}$" x 10"
Metropolitan Museum of Art
New York, Gift of
Henry Walters, 1917

Gauguin and Bernard were painting religious themes using representations of Christ, but he refused to turn from experience to imaginative illustration. Significantly, when he made a copy (Slide 18) of Rembrandt's etching, *Resurrection of Lazarus* (Figure 19), he omitted the figure of Christ; perhaps he felt it was something beyond his experience, even though he did copy a Christ by Delacroix.

Van Gogh's nervous strain and depression were increased by the doctors' total lack of hope for his recovery. Also weighing upon him was his failure to sell his pictures and so repay Theo's confidence in him. Even an article by Albert Aurier in the *Mercure de France* which praised him, and an invitation to participate in an important group show in Brussels, where one of his paintings was eventually sold, did not rouse his enthusiasm. Moreover, Theo had married while Vincent was in Arles and now a son, named Vincent after him, had been born; his sense of guilt at Theo's continued financial aid was heightened. Also, the conviction grew during his year at Saint-Rémy that the presence of the other inmates was intolerable because it aggravated his own condition, so that a move to new surroundings became necessary.

In May, 1890, at Pissarro's suggestion, Theo brought Vincent, after a short visit to Paris to see his nephew and some friends, to Auvers. There he was placed in the care of Dr. Gachet (Slide 19), who was himself an artist, a friend of Renoir, Cézanne, Pissarro, Sisley, and a man who even remembered Corot, Daumier, Courbet, and Monticelli. Although Dr. Gachet offered him every encouragement in his work, Van Gogh's dread of his recurrent attacks and the loss of hope for a complete recovery led him to shoot himself two months later. The bullet wound was not immediately fatal and he was able to return from the fields to his inn. Theo was summoned quickly. Two days later, on July 29, 1890, Vincent died. His death so affected Theo, that he too died insane in Holland six months later, and was buried beside his beloved brother in the cemetery of Auvers.

Towards the end of his stay at Saint-Rémy and during the months in Auvers, Van Gogh had extended his mature style until it became more abstract than his earlier manner. The drawing, *Cottage with Cabbage Patch and Cypresses* (Figure 20), illustrates the fantastic, curvilinear lines he began to find in nature. He mentioned primitive wood-block prints as a source, but if this is true, they were as much absorbed into his personal style as were the earlier influences of Dutch masters, French artists, and Japanese prints.

A tremendous vigor remains in Van Gogh's late style, well seen in one of his last paintings, *Crows over the Wheat Field* (Slide 20): its compulsive energy and vivid color foreshadow the Fauves and Expressionists of the present century, and live on in expressionist trends today. No other artist with so short a span of mature activity, a scant four years, had a comparable impact on the development of modern taste, nor opened the eyes of future generations so completely to the expressive potentials of painting.

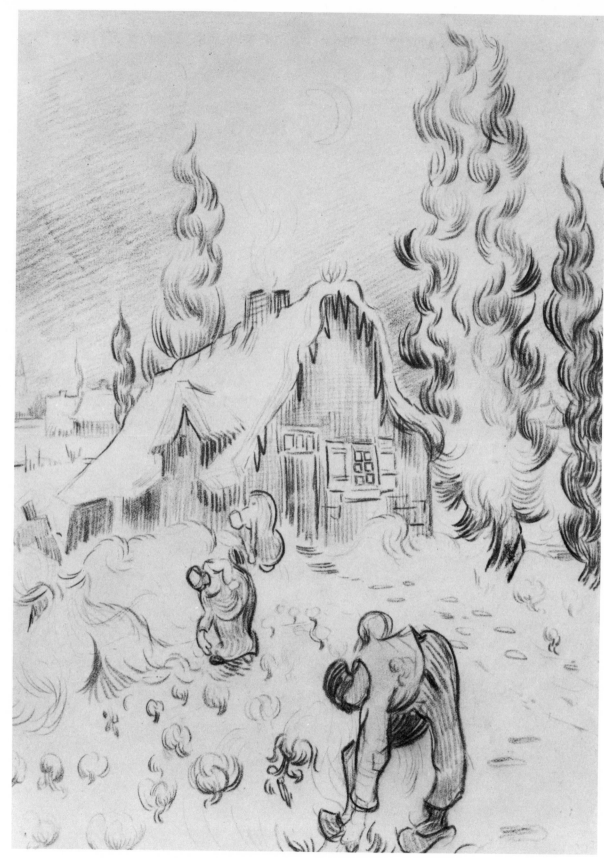

Figure 20.
*Cottage with Cabbage Patch
and Cypresses*
(1889–1890)
black crayon
12″ x 9¼″
Collection
Vincent van Gogh Foundation
Amsterdam

COMMENTARY ON THE SLIDES

COMMENTARY ON THE SLIDES

1: THE DRAWBRIDGE (Arles, March–April, 1888)
oil on canvas, 21½″ x 25½″ Rijksmuseum Kröller-Müller, Otterlo

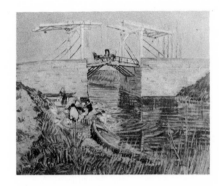

The small drawbridge near Arles, which Van Gogh drew and painted several times, closely resembled bridges he recalled from Holland, where they were a common sight. He must have been attracted to its familiar form soon after his arrival in southern France, and he has accounted with great care for all its structural elements, even to the ropes and pullies that operate it.

Looking at this mature picture, one can discern Van Gogh's whole artistic development. From the beginning he had been preoccupied with showing figures in a landscape—usually peasants at work—and had drawn them as boldly as he does here. After his early years in the Netherlands, where he had painted with dark colors (see Slide 2), he went to Paris. There, from the Impressionists and Neo-Impressionists, he learned to use strong, pure colors and to juxtapose complementary hues to gain more vivid effects. Also, he admired and even copied Japanese prints, the style of which is reflected here in the frankly drawn outlines, lack of shadows, and in the bright fields of color that convert the three-dimensional scene into a lively, nearly flat pattern.

Despite the half-submerged derelict boat in the foreground, the picture has an optimistic atmosphere. This pleasant effect arises in part from the women, busily washing clothes in the river, who give both scale and conviviality to the scene. But even more, the gaiety of the picture is created by the bright colors. The luminous blues of sky and water are a perfect foil for the light yellow timbers of the bridge and the ochres and terra cottas of its stone work. Interestingly, the shadowed undersides of the yellow timbers are painted in a near-complementary blue. Other almost complementary hues occur in the rusty browns and greens of the left foreground. Van Gogh's brushwork not only gives color, but animates every surface. Contrast the serene smoothness of the sky with the splintering of its reflection in the water, where bold strokes texture the surface with ripples and reflections of the bridge. The rough grasses of the foreground seem to grow because of the upward surge of Van Gogh's brush strokes.

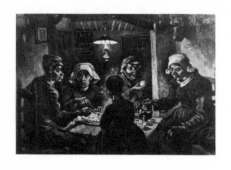

2: THE POTATO-EATERS (Nuenen, April–May, 1885), oil on canvas 32¼" x 45", Collection Vincent van Gogh Foundation, Amsterdam

An entire winter of drawing and painting peasants, especially their faces and hands, preceded Van Gogh's effort to group them into this composition. It was the largest and most complex picture he had attempted.

Keenly aware of the hardships in the peasants' way of life, he felt the picture was a tribute to their honesty and simplicity, themes that had deeply concerned him ever since he had begun to draw five years earlier. In letters to his brother Theo, he explained that he tried to show how these people, eating their scant meal of potatoes, had dug the earth with the same hands they stretched toward the dish, and so had honestly earned their food by manual labor. He thought it would be wrong to give such a picture "a certain conventional smoothness"; its very ruggedness should echo the peasants' existence. He realized people might not admire it at once, but explained: "If a peasant picture smells of bacon, smoke, potato-steam, all right, that's not unhealthy." Ultimately, he hoped his picture would give rise to serious thought about the relationship of art to life.

Van Gogh painted *The Potato-Eaters* partly from memory and partly while working in a peasant's cottage where he could study the effect of lamp light on the setting. He mentioned how dark his colors were, how far off-white were the women's hats and the tablecloth. He found that he had to repaint all the faces in darker flesh tones than he usually employed, finally using almost the color of an unpeeled potato, to give unity to the scene. Even so, each figure is so intensely seen for itself that the picture remains a sum of its parts rather than a totality. The heads and the hands have such vitality and human interest that one is inevitably forced to look at each separately, and one is disturbed by the jutting wall beyond the woman at the right for it seems to interrupt the composition unnecessarily. Such details are not essentially faulty, but they are unconventional. However, in his chief aim—"to bring *life* into it"—Van Gogh was certainly successful.

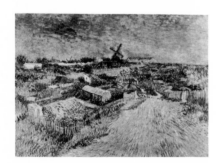

3: LITTLE GARDENS ON THE BUTTE MONTMARTRE (Paris, 1887) oil on canvas, 37¾" x 47½", Stedelijk Museum, Amsterdam

The Butte, or hill, Montmartre rises to the north of the center of Paris. Its name refers to the martyrdom of Saint Denis and his followers, the first Christian martyrs in ancient Gaul. Legend tells that the decapitated saint picked up his head and strode purposefully down the hill until he reached the spot where he wanted his church

to be founded. Today the area is engulfed within the city, but in Van Gogh's time it still preserved a country atmosphere even while accommodating the bohemian life of Paris.

In comparison with Van Gogh's Dutch work (Slide 2), this picture appears to be by a totally different artist. But, in fact, it shows Van Gogh responding sensitively to a new artistic environment. Now, no longer content with traditional realism, he is working in a revolutionary style. Through his brother Theo, Vincent was immediately introduced to Impressionists and Neo-Impressionists. Their broken touches of color found ready acceptance by Van Gogh, who had always admired a free, painterly approach. Yet the separate strokes of paint here are quite different from those in either Impressionist or Neo-Impressionist canvases (Figure 13), where they appear to lie on the surface and often reduce the picture to a shimmering, flat area of glowing color. Instead, Van Gogh's brush strokes are lengthened and placed in sequences that compel the eye to follow them. A compulsive plunge into deep space is demanded by the supernaturally animated surfaces of the road and fields and by the strongly marked receding diagonals of the perspective sustained by the placement of fences and buildings. Because of the three-dimensional draftsmanship in every touch of paint, the view grasps our attention with the intensity Van Gogh himself must have felt before it.

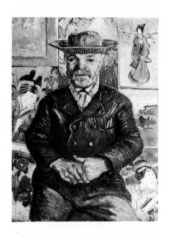

4: PÈRE TANGUY (Paris, 1887), oil on canvas, 25″ x 19″
Collection of Stavros S. Niarchos, Cap d'Antibes

With Père Tanguy, Van Gogh developed a warm feeling of friendship which was enthusiastically reciprocated. Tanguy was a Breton who had fought for the insurrectionary government, the Commune, that had taken over Paris for three months in 1871. Later, after being exiled and then granted amnesty, he had opened a color-grinding store not far from the rue Lepic where Van Gogh shared rooms with Theo.

Tanguy's wife disapproved of Van Gogh as a wasteful producer of unsaleable pictures. But in spite of this attitude, the painter must have spent considerable time with Père Tanguy, since he painted him three times, and even did a portrait of his wife. In Tanguy's shop he met Paul Signac, who became his good friend. There, too, he could study canvases by Cézanne, Pissarro, and Gauguin. Tanguy had a deep enthusiasm for the works of many young, unrecognized artists, and often traded paints, brushes, and canvas for their pictures. Quickly he agreed to exhibit Van Gogh's works.

Painted frontally, Tanguy appears almost like a diminutive Buddha against the background of exotic Japanese art. However, his Western costume, as well as the way

in which Van Gogh has painted him, sets him apart from the Oriental world. The strong, traditional contrasts of tone in the face, clothes, and hands distinguish him from the pale, unmodeled faces and flat areas of color in the prints behind him. These Japanese prints were undoubtedly something both he and Tanguy loved. Van Gogh had felt their attraction earlier in Antwerp, where he had hung some on his wall, and now, in Paris, where they had been admired for about twenty years, he could study them often.

Eventually, Japanese art was to have a strong influence on Van Gogh's whole concept of painting, but in Tanguy's portrait, he is still traditionally Western in his use of modeling and naturalistic space. One sees here, however, a most unorthodox exploration of the color theories of Seurat and Signac: bold, broken touches of red and green in the face and hands, and even stronger in the hat, where they are broadly brushed on opposite sides of the brim. The vibrant, bright red outline enclosing the blue-clad figure, a "halo" according to Chevreul's theory of seeing complementary colors surrounding each hue, is also almost unprecedented and exceptionally daring.

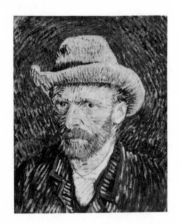

5: SELF-PORTRAIT (Paris, c. 1887), oil on canvas, 18″ x 15″
Collection Vincent van Gogh Foundation, Amsterdam

One of Van Gogh's most remarkable innovations under the influence of the Neo-Impressionists was to subject the human face to his own version of their pointillist technique. When broken into the tiny color dots of Seurat or Signac, a face might not have seemed incongruous in the original Neo-Impressionist technique, but with the lengthened strokes of Van Gogh, the familiar texture of skin is completely disintegrated for the sake of coloristic richness. Over a basic flesh tone of purplish-pink, strokes ranging from light yellow highlights to green and reddish-brown shades have been whipped over the surface in slashing strokes. Consistently, the hat, shirt, coat, and even the background show a welter of broken touches of color, some of them the black forbidden in the Neo-Impressionist palette. Such a transgression of the strict rules is characteristic of Van Gogh's attitude. As he wrote to his brother, ". . . this technique will not become a universal dogma any more than any other."

Van Gogh used Neo-Impressionist ideas of color flexibly because he was much more concerned with communicating emotion than with optically reconstituting effects of light in paint. However, during this formative Paris phase, when he must have felt he was still learning his art, he was quite willing to experiment with new techniques. Later he would make color his own agent to express sensations, emotions, and ideas, but this early experimentation liberated him from traditional uses of color.

6: THE ORCHARD (Arles, March, 1888), oil on canvas, 25½" x 32"
Collection Vincent van Gogh Foundation, Amsterdam

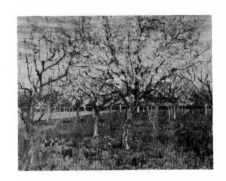

Van Gogh's naive pleasure at witnessing the advent of spring in southern France soon after his arrival in Arles is conveyed in this painting. Casting off his subservience to formative influences, he now responds directly to the scene before him, even though he has not forgotten his artistic sources; the Japanese prints live on in the outlines of his trees and in the "Oriental" calligraphy of the tree at the extreme left. Further, his Neo-Impressionist associations induced the reddish stubble among the green grasses. But now his vision is essentially his own. Even his early Dutch heritage is present in the simple enthusiasm he shows for the beauty of the flowering trees and in the subtle warm and cool colors of his sky.

One should realize that despite his participation in the school of Paris, the years of training in Holland left their mark on his whole production. His themes of intimate still life, of frankly humanistic portraiture, and of flat landscapes with picturesquely irregular trees recalling Hobbema, all have their precedents in Dutch art. In even as straightforward a picture as this, Van Gogh reveals the complex blend of artistic experiences he has made his own, and now they are coupled with his immediate response to the beauty of nature before him. With the intuition of genius, he is ready to express himself freely and directly.

Painting spontaneously, with the same headstrong zeal he had shown when ministering to the miners of the Borinage, Van Gogh now enters his mature style of painting. While he shows as yet no intimation of his final direction, attempting to symbolize emotions through colors and nervous outlines, he has still communicated the experience of simple surrender to the joy of the spring season, a time that was always significant for Van Gogh.

7: THE SOWER (Arles, June, 1888), oil on canvas, 24¾" x 31¼"
Rijksmuseum Kröller-Müller, Otterlo

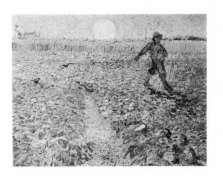

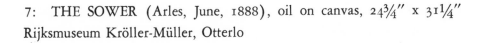

Despite his attachment to nature and his preference for real models, Van Gogh could not entirely resist painting from memory and imagination. Throughout his life he was haunted by the theme of the sower, which he developed in some thirty sketches and compositions.

In a painting such as this, apparently based on memory instead of an actual scene, we can see his ideas reflected most purely. Striving for maximum color intensity, Van Gogh contrasted a complementary violet ground and yellow sky. The violet,

however, is constructed of reddish browns and vivid blues, after the Neo-Impressionist method, and the yellow also contains broken tones.

The composition is daringly unstable: the sower, walking to the right, is balanced by a house with trees in the extreme distance. But the real center of the composition is the hypnotic sun, which transforms the sky from blue to warm yellow; it is a symbol of the true Creator, the fructifier, who will bring the sower's work to life. The sower, in Van Gogh's mind, became a symbol of himself as the creative artist, and wheat the symbol of humanity, to which he could only contribute through his art. The analogy of sun as God, sower as Van Gogh, and wheat as his inspired offspring—his work— is inescapable. Vincent wrote to his brother wondering if he would have the strength to carry out a large version of it, "hardly daring to think of it," because its significance was so interwoven with his personal life.

The painting itself reveals the quality of experiment, of striving, though hardly of turmoil and struggle. Its elements are not fortuitously fused. Avoiding the heroic scale of Millet's *Sower* (Figure 3), Van Gogh's figure fits unconvincingly, uncertainly, into the total composition. As yet, Vincent van Gogh is still humbly seeking his own role as a creator.

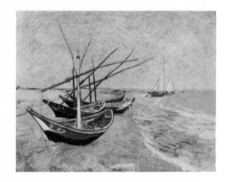

8: FISHING BOATS ON THE BEACH AT SAINTES-MARIES (Arles, June, 1888) oil on canvas, 25¼" x 32½", Collection Vincent van Gogh Foundation, Amsterdam

An unusual, carefree mood pervades much of the work that Van Gogh did on a trip he took from Arles to nearby Saintes-Maries on the Mediterranean coast. Here he drew and painted for several days, freely responding to the scenes before him. In the landscape, he borrows the rough brushwork of the Impressionists without bothering himself over complex color theories, but he is clearly seeing the boats on the shore in terms of Japanese prints; they are described in clear outlines, without shadows, and their coloring is as flat and bold as in the Oriental style.

One should always look for surprises in Van Gogh's coloring, and, to be sure, they are present here. The vivid yellow mast of the foremost boat is crossed by a brilliant orange-red spar. The latter note of color is echoed in the boat itself and then carried in touches across the vessels on the sea to the far horizon, where one red sail carries this color note from left to right of the composition. Here is evidence of an aesthetic preoccupation, which one suspects was learned chiefly from Japanese prints. The contrast of red and blue, declared in the nearest boat, becomes a pictorial motif throughout the picture; the warm and cool hues of sand, sea, and sky set off the major theme. It

is surprising that so aesthetic a synthesis took place in Van Gogh's mind under the guise of so spontaneous a reaction to the scene. The fact that interest centers on the name of the boat, *Amitié* (Friendship), and that his signature is centered immediately below it, is a pathetic witness to his loneliness.

9: LA MOUSMÉ (Arles, July, 1888), oil on canvas, 28⅞″ x 23¾″
The National Gallery of Art, Washington, D.C., Chester Dale Collection

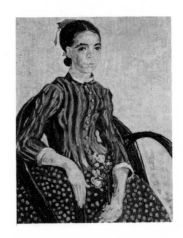

Mousmé is a French transliteration of the Japanese word for a young girl, "Provençal in this case—12 to 14 years old," as Van Gogh wrote to Theo. In other words, he has painted a young peasant girl of southern France, and named her according to his fascination with all things Japanese; ". . . you will understand when you have read Loti's *Madame Chrysanthème*," he tells his brother.

The linear structure of the picture, clearly marked in the figure and in the outlines of the chair, is derived from Van Gogh's "Japanese" vision, but the modeling of the girl's face, with delicate contrasts of warm and cool tones, makes a concession to the Western tradition of modeled forms.

It is interesting to see how he has applied Neo-Impressionist color theories here in a totally new, individualistic way. Against a luminous green background, that is as primary in terms of light as the pure green of a traffic light, he sets the vibrant blues, oranges, and reds of the girl's dress which both balance and reinforce each other. This chromatic harmony is further extended by the green and blue tones of the flesh, the touches of red in the ear, and the tinge of violet in the hair.

The hands, in their apparently "unfinished" state, are especially interesting. Van Gogh is not painting to fool the eye with a clever photographic imitation of nature; his picture is "finished" when he has incorporated his emotional feeling about his subject. In the same way, the oleanders in the girl's left hand are summarized with extraordinary breadth of style; they are not an end in themselves, but only a part in the total scheme.

In describing the painting, Vincent indicated he had arbitrarily used vivid hues to convey his feeling of the girl's gaiety "by the sheer radiance of color." Yet the impression of the portrait is not gay. In fact, the wistful expression, combined with a certain tenseness and a self-conscious restraint in the pose suggests quite a different mood and indicates that (contrary to Van Gogh's intention) the capacity of colors or color combinations alone to symbolize emotional states is not sufficiently strong. In an abstract painting colors may intimate rather general emotional atmos-

pheres, but in a representational picture such as this portrait, intended color-emotion equations may be easily outweighed by facial expression, gesture, and pose unless they augment each other. Frequently, Van Gogh's portraits acquire an arresting, enigmatic quality from this lack of correlation.

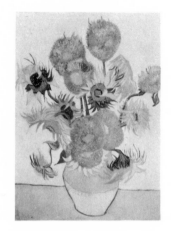

10: SUNFLOWERS IN A VASE (Arles, August, 1888), oil on canvas 37¾" x 29", Collection Vincent van Gogh Foundation, Amsterdam

In his eagerness for companionship in Arles, Van Gogh expended great efforts to make his rented home acceptable to Gauguin, whose visit was long anticipated and fretfully solicited in letters. He did a series of paintings of sunflowers to decorate the rooms in the house, evidently feeling, and rightly, that they would appeal to Gauguin.

For its success, Van Gogh's series of sunflowers relies chiefly upon closely related hues in the spectrum, red, orange, ochre, yellow, and brown; the harmony is secured by allied colors, close to each other on the color wheel. To be sure, touches of blue and green are included to offset the warm tones, and there are spots of varying green in the center of each sunflower. (Some of his other sunflower paintings even have a light blue background.) In fact, in the specific colors he used, Van Gogh constantly offers more variety of tints and shades than one expects. Upon a "Japanese" stylization is grafted the Western tradition of color variation, so that there is always greater use of hue and tone than one finds in the conceptualized art of the Orient.

Had the sunflowers a meaning beyond their mere visual appeal for Van Gogh? Undoubtedly they became a personal symbol; turning as they do toward the sun, they were like Van Gogh, who had gone to the south of France in search of sunlight.

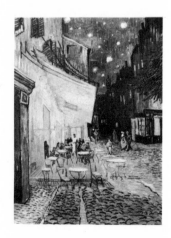

11: SIDEWALK CAFÉ AT NIGHT (Arles, September, 1888), oil on canvas 31" x 24¾", Rijksmuseum Kröller-Müller, Otterlo

"The night is more alive and more richly colored than the day," Van Gogh once wrote to his brother. What a wonderful contrast he has found between the lighted facade of the sidewalk café and the intense dark of the buildings beyond it! The star-studded sky is an anticipation of his ultimate fascination with this theme, which he first experi-

enced at Arles and later revealed with astonishing intensity at Saint-Rémy in *Cypresses by Moonlight* (Figure 18).

Van Gogh was at this time also experimenting in painting night scenes from nature, with candles attached to his hat to help him see his canvas. Not surprisingly, the people of Arles thought him eccentric in these endeavors. Yet, here were founded the experiences that later produced some of his most famous canvases (Slide 17).

This is not a picture of the exterior of the well-known *Night Café* (Slide 12). It shows another café, among the many in Arles, and has no special associations with Van Gogh's biography. Nevertheless, he has seen it with his usual intensity. The eye is led inward from the glowing, warm hues of the café, yellow and orange with a startling green in the shadow, toward cold blues and blacks in the distance. Intermediary grayed purples occur in the superstructure of the café and are conjured Neo-Impressionistically in the foreground pavement from blues and rusty reds, interspersed with unorthodox black strokes. Notice also the contrast in perspective between the doorway at the extreme left and the rest of the picture. This doorway hardly fits in a conventional way with the rest of the composition, but how dramatically it is *seen* as an element at the artist's left. It represents a separate act of seeing, comparable with Cézanne's late vision and the multiple perspectives of Cubism. Such is Van Gogh's daring that he overrides tradition in seeing for himself, and thus anticipates the future course of painting in our own century.

12: THE NIGHT CAFÉ (Arles, September, 1888), oil on canvas, 27½″ x 35″ Yale University Art Gallery, New Haven, Stephen C. Clark Collection

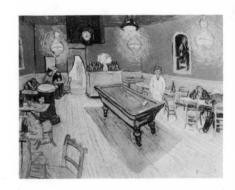

Although Van Gogh described this picture as "one of the ugliest I have done," it is one of his most famous because it illustrates his expressive aims most clearly. "I have tried to express the terrible passions of humanity by means of red and green," he wrote to Theo, and he characterized the scene as "a place where one can ruin one's self, run mad, or commit a crime." In his very subjective view it had "an atmosphere like a devil's furnace, of pale sulphur." A *café de nuit* stayed open all night and was tolerant of night prowlers, who took refuge there when they had not the money to pay for a night's lodgings or, as Van Gogh wrote, "are too tight to be taken to one."

Van Gogh sat up for three nights and slept during the day while painting this. His dominant colors are the complementaries red and green. The "blood red" as he called it, which contains a tinge of purple, is an alien foil to the varied greens on table tops, billiard table, bar, stove, and ceiling. It is characteristic of Van Gogh's coloring

that he varies these greens so that they play through a gamut of hues and tones, from the cool dark ceiling through the emerald green of the billiard table to the light warm green of the bar and the aqua hues of the tables. Although he wrote of a "Japanese gaiety" in this coloring (despite his other references to its macabre associations), his use of color is not Japanese. As noted in relation to his *Sunflowers* (Slide 10), his hues are far more varied than those in Japanese prints. Here the variety of greens joins with multiple tones of ochre and yellow, another major color theme. Also more variations are wrought on the red wall by the lights with their remarkable orange halos. All these hues give a richness of color which is not part of the Oriental style, but developed chiefly from Van Gogh's own sensibility.

Since he refers to both gaiety and depression stemming from his colors in this painting, Van Gogh would appear to have been in doubt about the effectiveness of symbolizing his emotions in color combinations. But this very conflict between exaltation and revulsion may have been his true reaction to the subject. Van Gogh's concern with symbolizing his feelings in color more than one month prior to his close association with Gauguin, which began in October, 1888, is important to notice because it indicates his independent pioneering in the Expressionist movement.

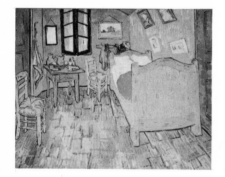

13: THE BEDROOM AT ARLES (Arles, October, 1888), oil on canvas 28½″ x 36″, The Art Institute of Chicago

Van Gogh rented a small house in Arles, both to secure a satisfactory working space for himself and to have accommodation for another painter who might help him establish a "school of the south," the communal artist colony he passionately hoped to found. Here he and Gauguin lived together for about three months.

With his drive to communicate his every thought and feeling to his brother Theo, Van Gogh painted this view as a sort of progress report to show how his efforts at furnishing the house were developing. A surprisingly wide-angle view includes three walls and a floor, seen in sharply rising perspective, which draws the spectator into intimate participation in the scene. The simple furniture takes on impressiveness from this perspective; the bed becomes monumental, the chairs and table assert themselves with their clear, angular forms seen from above.

Van Gogh hoped that "to look at the picture ought to rest the brain or rather the imagination," the whole scene "suggestive of *rest,* or sleep in general." To reinforce this feeling, he has painted the floor predominantly in green hues, whereas in fact it

was red as it appears in another version, and as witnessed by his description to Theo. Here the green and the cool blue-violet of the walls are an obvious foil for the warm colors of the furniture. Besides this balance of color, a balance of forms is created between the chair and table at the left and the bed at the right. Thus, in relation to Van Gogh's generally turbulent style, the picture is restful. The suppression of dark shadows, as in Japanese prints, allows the picture to resolve itself into a broad color pattern.

14: THE IRON BRIDGE OF TRINQUETAILLE (Arles, October, 1888)
oil on canvas, 28¾" x 36⅛", Collection of Dr. Sonja Kramarsky Binkhorst, New York

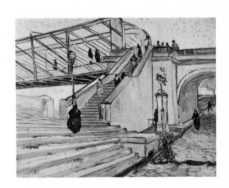

The Bridge of Trinquetaille across the Rhône river afforded one of the main approaches to the city of Arles. Destroyed in World War II, it was later rebuilt in a different form. In painting the old concrete and iron structure on a gray, overcast day, Van Gogh accepted the unusual challenge of working almost monochromatically. His love of color, however, led him to enhance the warm-cool contrast between the cold blue of the ironwork and warm neutral hue of the concrete. Blues and greens are picked up in shaded areas of the steps and below the surface of the bridge. Only a touch or two of orange and yellow intrudes upon the general neutrality of the colors. Such restraint in color is remarkable for Van Gogh, but he probably looked upon the subject chiefly as a challenge in draftsmanship. The perspectives of the two flights of steps at right angles to each other, or of the road below eye level and the bridge overhead, again at right angles to each other, posed problems in drawing, but they also gave a clarity to the design that undoubtedly attracted him.

One of the painter's major satisfactions in looking at nature is to find it suddenly arranged in patterns familiar to his art. Here, besides the underlying solid geometry of the main forms already noted, there are other interesting concordances. The foreground tree bisects the kiosk, which, in turn, bisects the concrete buttress of the bridge behind it. A balancing vertical line is extended from the foremost figure on the steps, to the lamp post behind it, and into the structure of the bridge. Such concurrences of outlines, perhaps born of an accidental point of view, become important compositional devices when fixed in the painting. Here they flank the monumental girders at the end of the bridge, which become an inevitable center of interest because so many lines and accents converge toward them. Intuitively, Van Gogh was able to see commonplace nature in these formal pictorial terms.

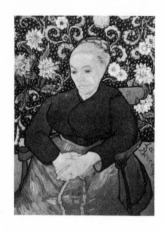

15: LA BERCEUSE, also known as WOMAN ROCKING A CRADLE
(Arles, January–February, 1889), oil on canvas, 36⅜" x 28¾"
Rijksmuseum Kröller-Müller, Otterlo

This is a portrait of Mme. Roulin, wife of the postman who was Van Gogh's good friend in Arles. The rope shown in her hand is for rocking a cradle; Van Gogh intended her to personify motherhood. He repeated the composition four times, varying its details slightly, especially in the flowers on the wallpaper in the background.

In painting this work he has been deliberately more crude than in most of his pictures, and he likened the picture to a "chromo-lithograph from a cheap shop." Thick black lines, sometimes surprisingly angular, define the figure and the chair, and contain unmodeled flat fields of color. The skirt and face are very simply modeled with few color changes. Although the picture is coarsely painted, it is not lacking in color subtlety. As Van Gogh explained it, the discordant colors, such as the green skirt, orange hair, pink and green background, were softened by their contrast with the broad, flat areas of red and green. He hoped the picture would be hung between two of his studies of sunflowers, because he felt that the colors of the face and hair would "gain more brilliance by the proximity of the yellow" in those pictures. "I want to say something comforting as music is comforting," he wrote. "I want to paint men and women with that quality of the eternal that the halo used to symbolize, and which we try to give by the actual radiance and vibration of our coloring."

The primitivism of *La Berceuse* is only partially explained by Van Gogh's knowledge that Gauguin and Bernard were using just such bold simplifications; it may have been also that Van Gogh thought of this picture as a piece of folk art. He recalled conversations with Gauguin about Icelandic fishermen and their "mournful isolation" and constant exposure to dangers which he had read about in a novel by Pierre Loti. To Theo he expressed the hope that sailors, "who are at once children and martyrs," seeing this picture in the cabin of their boat, "should feel the old sense of cradling come over them and remember their lullabies." Such apparently far-fetched, sentimental associations undoubtedly gained force from Van Gogh's own feelings of isolation and fear after his first attack of insanity.

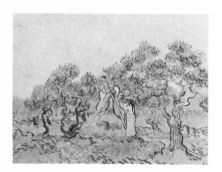

16: THE OLIVE ORCHARD (Saint-Rémy, November, 1889)
oil on canvas, 28¾" x 36¼"
The National Gallery of Art, Washington, D.C., Chester Dale Collection

Frequently allowed to leave the asylum near Saint-Rémy where he had placed himself, Van Gogh often painted the olive orchards in the neighborhood. A letter from Émile

Bernard describing his painting of *Christ in the Garden of Olives* and the knowledge that Gauguin was painting the same subject increased Van Gogh's interest in the theme and gave his work a certain missionary zeal. He protested to Bernard that reality, or actual experience, was the only sound inspiration for the painter. Rather than imagine Biblical scenes, he preferred to paint what immediately stimulated his eyes.

Among his many views of olive orchards, this one has softer, less intense coloring than most. A letter to his brother explains this muted color by saying that he is trying to recall trees seen during his youth in Holland, for he planned to send the picture to his sister and did not want to startle her with too vivid colors.

While he may have toned down the colors to stress gentle silvery greens with an occasional touch of blue, purple, and earth hues, he has in no way curtailed his fascination with rhythmic surfaces on the ground and in the twisting tree trunks and branches. Even the leaves do not hang down, realistically responding to gravity, but seem to swirl upward, perhaps to reveal intensely the power of life and growth.

To describe the three women picking olives Van Gogh adopted a primitivistic, bold, dark outline filled with flat colors. There is a correlation between the simple actions of the peasants and his style of recording them. In this he harks back to his early major interest in the peasantry, but in the strength of outlines he anticipates his most mature development in Auvers.

17: ROAD WITH CYPRESSES (Saint-Rémy, February, 1889)
oil on canvas, 36¾" x 29", Rijksmuseum Kröller-Müller, Otterlo

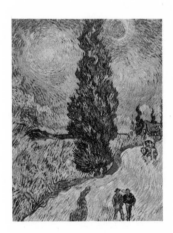

Filled with a disturbing restlessness, the jagged lines and sinuous curves in this curious night scene are stabilized by the soaring mass of the cypress tree and the two huge celestial orbs. On the left is a star "with exaggerated brilliance, if you like, a soft brilliance of rose and green in the ultramarine sky." On the right is a crescent moon "without radiance."

Although painting a scene illuminated only by pale moonlight, Van Gogh has hardly diminished his colors below their daylight level. As he had intensified the sun-bleached colors of Arles to reflect his love of the sun, so he preserved for emotional reasons the vitality of the night and sustained a surprising color brilliance in the field of cane, the cypresses, the sky, and in the distant yellow cart and green-roofed house with its lighted window. Only the road, which shines mirrorlike and catches reflections of green, blue, and yellow, conveys the experience of a night scene.

Despite the excitement of varied directions in the brush strokes, the writhing of clouds, trees, and earth, the picture maintains a sense of calm as if a resolution of anxieties and tensions had been found in the infinite wonder of the cosmos.

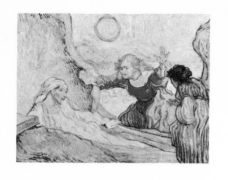

18: THE RESURRECTION OF LAZARUS (Saint-Rémy, May, 1890), oil on canvas 18⅞″ x 24½″, Collection Vincent van Gogh Foundation, Amsterdam

Soon after recovering from the last mental attack he suffered at Saint-Rémy, Van Gogh painted this variation of an etching by Rembrandt. It is one of many copies he made after various prints Theo sent him at the asylum—Millet, Daumier, Delacroix, as well as Rembrandt—and which he translated into his own style and coloring.

Figure 19 illustrates Van Gogh's source for this painting. He has omitted entirely Rembrandt's splendid figure of Christ and all the marveling spectators at the miracle. This "copy" is in fact exceptional in his work for singling out and radically varying a part of another master's picture. It probably had an autobiographical implication, for, quite reasonably, one can see in the face of Lazarus Van Gogh himself, recently revived from a serious recurrence of his mental illness. The omission of Christ and the substitution of the sun, which permeates the whole composition with yellow, is interesting in view of Van Gogh's reluctance to follow Bernard and Gauguin into Biblical illustration (see discussion of Slide 16); the sun became his symbol of God manifest to man's senses.

In comparison with Van Gogh's original works, based on his own perception of nature, such a "copy," even with its very personal emendations, cannot compete; it remains theatrical. For his own talent, Van Gogh surmised correctly that inspiration must derive from his own experiences of life.

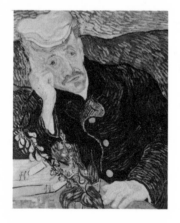

19: PORTRAIT OF DR. GACHET (Auvers, June, 1890), oil on canvas 26″ x 22⅜″, Collection of Mrs. Siegfried Kramarsky, New York

Van Gogh painted Dr. Gachet with "the expression of slight distress characteristic of our times." Gachet himself suffered from nervous tension and his afflictions brought a ready understanding of Van Gogh's problems. They became friends at once when Theo submitted his brother to Gachet's care at Auvers in May, 1890. Gachet was an artist of considerable competence, so, again, he and Van Gogh found much in common. Apropos of the portrait, it is interesting to compare it with Van Gogh's description of his ideal portrait of an artist—"a friend, a man who dreams great dreams." Van Gogh stipulates that this artist must be a fair man and he wants to put into his picture his appreciation and love for him. At first he paints his ideal artist as he appears, as faithfully as he can; but the picture is not finished Van Gogh says, for now he must become an "arbitrary colorist" and exaggerate the fairness of his hair, using chromes,

orange tones, and pale lemon yellow. "Beyond the head, instead of painting the ordinary wall of the mean room, I paint infinity, a plain background of the richest, intensest blue." So Van Gogh hoped to achieve a "mysterious effect, like a star in the depths of an azure sky."

Here his ideal portrait undoubtedly is compromised by the reality of his subject, an aspect of portraiture to which Van Gogh was ever keenly responsive. He does not in this case, nor would he have wished to, escape the genuine character of his model, and Gachet emerges a wholly fallible, rather than ideal, human being. But the "arbitrary colorist," who can give a power to painting beyond nature itself, is evident in the vivid reds on the table top juxtaposed to the green leaves of the plant, or the bright yellow of the books against the blue coat and background. The quite vivid green hues, used to give detail in the face and hands, become entirely acceptable in the general intensity of the total picture.

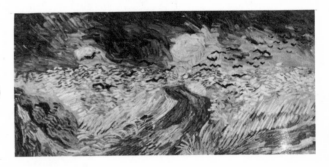

20: CROWS OVER THE WHEAT FIELD (Auvers, July, 1890)
oil on canvas, 20″ x 40¾″
Collection Vincent van Gogh Foundation, Amsterdam

The most cataclysmic vision of nature Van Gogh experienced is conveyed in this canvas, one of the last he painted. Yet for him, although it expressed sadness and loneliness, it also showed "the health and strengthening" that he saw in the country. The paradox can be resolved in emotional terms; it is not an "either-or," but can be both a confession of torment and a consolation.

In the wild energy of his brush strokes, Van Gogh surrenders to his subjective vision. Three seething paths through the wheat fields converge as if in torrents of energy upon the foreground. Black crows, like harpies, relentlessly wing their way forward. Two distant clouds leap toward us, while the wheat surges wildly into the distance. This astonishing concept, so different from the radiant optimism of Van Gogh's Arles period, had grown slowly through the months in Saint-Rémy and Auvers. Here lucid perception has deserted him, and he paints from obsessive compulsions, reversing perspective and even tonal contrasts in the dark sky and luminous fields. Yet the struggle to achieve order among rampant sensations is present in the broad organization of the scene into elemental earth and sky; these data are held despite the riot in each of them.

Van Gogh's abandonment in paint application had started, of course, much earlier, and had been developed in defiance of convention. "I lay the paint freely on the canvas

with irregular strokes quite unsystematically . . . lumps of paint here, patches of bare canvas there." He went on to say that the result was disquieting and "provoking enough to shock those with preconceived ideas on technique." So completely had this unorthodox style become his own that here it is automatic, and fights for control of the picture against his perceptions of the scene; it becomes a liberator from conventional ways of seeing and asserts the primacy of paint as the source of suggestion. Subconsciously, then, Van Gogh is led beyond the limits of nineteenth-century vision into a powerful anticipation of abstract expressionism.